BANKSY

~~ART~~ BREAKS THE
RULES

WRITTEN BY **HETTIE BINGHAM**

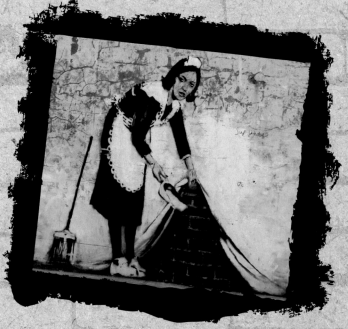

WAYLAND

www.waylandbooks.co.uk

First published in 2014 by Wayland
Revised edition published in 2016 by Wayland

ISBN: 978 0 7502 9976 3
10 9 8 7 6 5 4 3 2 1

Printed in China

MIX
Paper from
responsible sources
FSC
www.fsc.org
FSC® C104740

Wayland
An imprint of
Hachette Children's Group
Part of Hodder & Stoughton
Carmelite House
50 Victoria Embankment
London EC4Y 0DZ

An Hachette UK company.
www.hachette.co.uk
www.hachettechildrens.co.uk

Cover design by Nic Davies at Smart Design Studio
Interior design by Dynamo
Additional design by Lisa Peacock
Written by Hettie Bingham
Editor: Elizabeth Brent

Picture acknowledgements:
Alamy Cover Kathy DeWitt, p21 mr Stefano Baldini; p29 tr Kathy DeWitt; REX
p16 tr Adrian Sherratt; p18 mr Rex; p19 m Sipa Press; Corbis p23 Mohammed
Saber/epa; p36 Paul Green/Demotix; p45 Till Jacket/Photononstop Getty p22
Anadolu Agency; p24 AFP/Philippe Huguen; p25 Carl Court; Shutterstock
Backgrounds and Doodles: Pixotico; Edvard Moinar; Banana Republic Images;
Mike McDonald; Apartment; GreenBelka; schab; Prapann; Alexandra Dzh;
Larysa Ray; Butenkov Aleksei; McLura. p1 m, p29 b BMCL; p8 bl; p32 tr 360b;
p33 br anderm; p12 br, p13 bl, p14 tr, p15 tr, p17 bl, p43 m; p9 tr David
Fowler; p34 m Donald Bowers Photography; p33 tr Frank Wasserfuehrer; p20
m Jeremy Reddington; p30 tr, p31 br Padmayogini; p2 tr, p28 br Radoslaw
Lecyk; p4/5 m Yoann MORIN; p6 m BasPhoto; p7 b 1000 Words; p10 bl 1000
Words; p11 t meuniard, m t. natchai, b EQRoy; p26–27 photogeoff; p38–39
BasPhoto; p40 BasPhoto; p41 t BasPhoto, b Lucie Lang; p44 tl BMCL, br 1000
Words

CONTENTS

CONTENTS

WHO IS BANKSY?

Who exactly is Banksy? His identity is a closely guarded secret, but we're pretty sure that he's a man and it is thought he comes from Bristol. We don't know his real name, his exact age or anything about his family ...

There are some things we do know about Banksy, though. We know some of his opinions, his original sense of humour and his unique perspective on life. These are things we can learn about him through his art.

Banksy's art is public. He draws on walls because he wants the world to see and understand his take on life. His art can have a funny message or a serious one, but all his works are designed to make us think and to look at things from a different angle.

A LOT OF PEOPLE NEVER USE THEIR INITIATIVE BECAUSE NO ONE TOLD THEM TO.
BANKSY

ART SHOULD COMFORT THE DISTURBED AND DISTURB THE COMFORTABLE.
BANKSY

Graffiti art by Banksy
in Passage Du Moulin
Des Pres – October 2012

> ALL ARTISTS ARE PREPARED TO SUFFER FOR THEIR WORK, BUT WHY ARE SO FEW PREPARED TO LEARN TO DRAW?
> BANKSY

They seek him here, they seek him there

Banksy has given very few interviews to journalists over the years (and with no guarantee that it was really him), but he has never allowed his photograph to be taken. On the rare occasions he has been filmed, he was heavily disguised. Only a few trusted friends know his true identity. Bansky has revealed that even his parents didn't know who he was – they thought he was a painter and decorator. Perhaps they still do!

> THERE ARE NO EXCEPTIONS TO THE RULE THAT EVERYONE THINKS THEY'RE AN EXCEPTION TO THE RULES.
> BANKSY

> IT DOESN'T TAKE MUCH TO BE A SUCCESSFUL ARTIST - ALL YOU NEED TO DO IS DEDICATE YOUR ENTIRE LIFE TO IT. THE THING PEOPLE MOST ADMIRED ABOUT PABLO PICASSO WASN'T HIS WORK/LIFE BALANCE.
> BANKSY

UNMASKING BANKSY

Although Banksy's identity remains unknown, speculation as to who he really is is rife throughout the media and on the internet. Some theories put forward include:

* THAT HE'S ROBIN GUNNINGHAM, A FORMER PUPIL AT A PUBLIC SCHOOL IN BRISTOL.

 THAT HE'S A PAINTER AND DECORATOR FROM BRISTOL CALLED ROBIN BANKS.

* THAT HE'S ACTUALLY THE FAMOUS ARTIST DAMIEN HIRST.

THAT HE'S A GRAFFITI ARTIST CALLED KING ROBBO.

* THAT HE IS, IN FACT, A SHE.

THAT HE'S MANY PEOPLE, AND 'BANKSY' IS ACTUALLY AN ART COLLECTIVE.

 * THAT HE'S A HUMOROUS STREET ARTIST CALLED MR BRAINWASH, WHO APPEARED IN BANKSY'S 2010 DOCUMENTARY *EXIT THROUGH THE GIFT SHOP*.

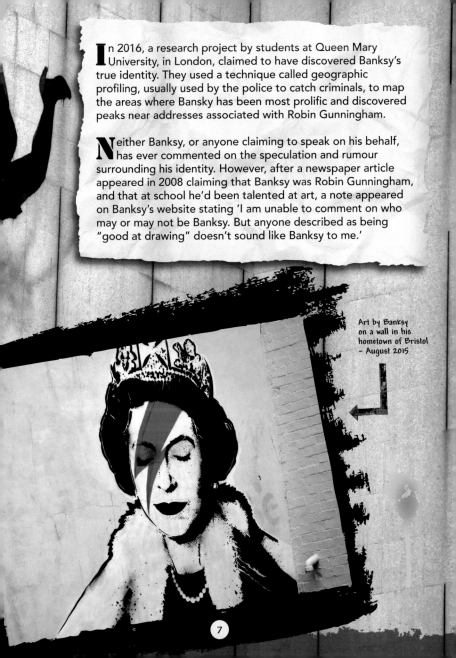

In 2016, a research project by students at Queen Mary University, in London, claimed to have discovered Banksy's true identity. They used a technique called geographic profiling, usually used by the police to catch criminals, to map the areas where Bansky has been most prolific and discovered peaks near addresses associated with Robin Gunningham.

Neither Banksy, or anyone claiming to speak on his behalf, has ever commented on the speculation and rumour surrounding his identity. However, after a newspaper article appeared in 2008 claiming that Banksy was Robin Gunningham, and that at school he'd been talented at art, a note appeared on Banksy's website stating 'I am unable to comment on who may or may not be Banksy. But anyone described as being "good at drawing" doesn't sound like Banksy to me.'

Art by Banksy on a wall in his hometown of Bristol – August 2015

7

EARLY WORK

During the 1990s, the city of Bristol was establishing an underground culture of street art and graffiti that continues to this day. Back then, it was claimed that Banksy was part of a Bristol graffiti crew known as DryBreadZ (DBZ). Now he is one of the world's most famous contemporary artists.

Inspired by the graffiti artist 3D, who formed the music group Massive Attack, Banksy started making graffiti in the classic New York style with big, spray-painted letters. In a rare interview, he admits that he was never very good at working in that way because it took him too long to do. He needed to come up with a way to produce his work more quickly; he was worried he would get caught by the police, because what he was doing was against the law. Eventually Banksy decided he could work faster using stencils, and he has been using this technique since around the year 2000.

Banksy's work began to appear in Bristol and London. Around this time he met Steve Lazarides, a photographer-turned-art-dealer, who began selling Banksy's work and later became his agent. Steve worked with Banksy until 2009, when the pair parted company for reasons unknown.

This graffiti piece in Bristol by Banksy prompted Bristol City Council to ask the public whether graffiti should be left or removed.



8

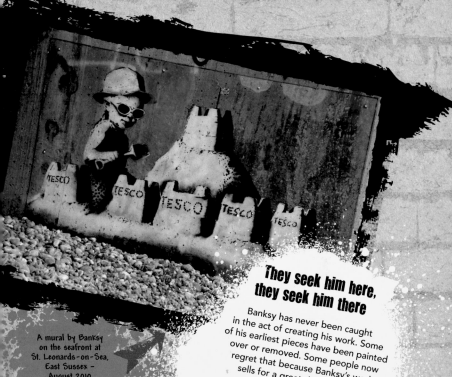

A mural by Banksy
on the seafront at
St. Leonards-on-Sea,
East Sussex –
August 2010

They seek him here, they seek him there

Banksy has never been caught in the act of creating his work. Some of his earliest pieces have been painted over or removed. Some people now regret that because Banksy's work sells for a great deal of money these days!

I CAME FROM A RELATIVELY SMALL CITY IN SOUTHERN ENGLAND. WHEN I WAS ABOUT 10 YEARS OLD, A KID CALLED 3D WAS PAINTING THE STREETS HARD. I THINK HE'D BEEN TO NEW YORK AND WAS THE FIRST TO BRING SPRAY PAINTING BACK TO BRISTOL. I GREW UP SEEING SPRAY PAINT ON THE STREETS WAY BEFORE I EVER SAW IT IN A MAGAZINE OR ON A COMPUTER.

BANKSY

GRAFFITI AND STREET ART

Street art as we know it today began in big cities in the US in the 1970s, when young people started writing their names, or 'tags', on walls. The trend caught on, and people began using aerosol paint to graffiti. Tags became bigger and more colourful, and artists started to use graffiti to make pictures and decorate walls – and sometimes even methods of transport, such as trains or buses.

Although it is illegal in some countries (including the UK), in other countries there are designated 'graffiti zones', where street artists can work without fear of reprisal. There is one such zone in Sao Paulo, in Brazil, that attracts thousands of visitors every year. Street art is slowly becoming more mainstream, too. There have been graffiti exhibitions all over the world, and there's even a street art festival in Bansky's hometown of Bristol that takes place in the summer every year.

FAMOUS STREET ARTISTS INCLUDE:

Os Gemeos – These identical twin brothers from Brazil play a major part in the country's street art culture. Their colourful work has been commissioned and displayed all around the world, from North America to the UK and Portugal.

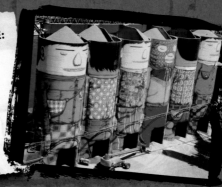

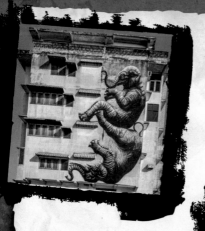

ROA – A Belgian artist, ROA usually paints animals or birds native to the area he is working in. Beautiful and intricate, his murals have been commissioned to decorate walls from Thailand to New Zealand.

C215 – The pseudonym for French artist Christian Guémy, who has been described as the French Banksy. C215 principally paints close-up portraits of people such as refugees, the homeless and the elderly.

IS IT ART?

'TO ME THERE'S NOTHING AT ALL INTERESTING ABOUT BANKSY ... WHEN I SAW HIS STUFF AROUND I THOUGHT, "WELL, THAT'S AN ENTERTAINING BIT OF RUBBISH ON THE WALL." BUT NOW I'M SUPPOSED TO TAKE ALL THIS STUFF SERIOUSLY AND I DON'T REALLY KNOW WHAT I'M SUPPOSED TO SAY; IT'S QUITE OBVIOUS THAT HE ISN'T REALLY ANYTHING.'

— MATTHEW COLLINGS, ART CRITIC

Art critics and the public are divided when it comes to Banksy's status as an artist. Some think he is a vandal, but many believe he's a genius. There are fans of his work all around the world and his style is mimicked everywhere. His designs can be found on T-shirts, calendars and even cushion covers – much the same as Van Gogh's famous *Sunflowers*, for instance. Banksy's work is now more commonly found in art galleries than on a brick wall, and it sells for large amounts of money when it comes up at auction.

Banksy's *Sunflower*, located in Bethnal Green, London – November 2007

Islington Council in North London spends a great deal of money removing illegal graffiti. However, it has taken the view that Banksy's work is public art and it sees it as a gift. It never removes work that is thought to be by Banksy.

'ART HAS ALWAYS BEEN INTERESTED IN REBELS ... [BANKSY'S WORK] IS TYPICAL SUBVERSIVE ART BEHAVIOUR. IT'S WHAT ART DOES; IT GETS UP THE NOSES OF THE ESTABLISHMENT.'

— WALDEMAR JANUSZCZAK, ART CRITIC

IS IT LEGAL?

Putting graffiti on a wall that doesn't belong to you is against the law in the UK under the Criminal Damage Act 1971. Graffiti is seen by many as a public nuisance, and is often associated with gang culture and anti-social behaviour.

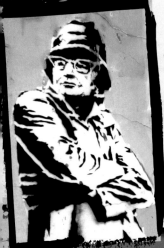

Banksy's *Pensioner Thugs* in London – December 2007.

Graffiti can be defined as drawings, scribbles, messages or tags that are painted, written, sprayed or etched on to walls or other surfaces. Anyone convicted of creating graffiti in the UK can be imprisoned, fined or ordered to do community service, depending on how much damage has been caused. However, there are ways of making street art that is legal. Some councils and private businesses provide special walls or structures for people to decorate with graffiti so that street artists are able to showcase their work.

There is no doubt that some of Banksy's work has been carried out illegally. He keeps his identity such a closely guarded secret because he knows that if the police catch him he will be prosecuted.

GETTING NOTICED

Once he had established his distinctive stencil style of graffiti in 2000, Banksy spent the next few years coming up with original ideas for his art. His pieces became a familiar sight on city streets: not just in London and Bristol but in places as far afield as the USA and Palestine in the Middle East. If people didn't yet know his name, they were certainly getting to know his work.

Banksy's London Doesn't Work, City of London – December 2007

Banksy's work began to attract the attention of the media, and the public began to look out for his stencils, waiting to see what would come next. He didn't disappoint: along came pictures of kissing policemen, rats holding placards, monkeys with weapons of mass destruction and the characters from the film *Pulp Fiction* holding bananas instead of guns.

They seek him here, they seek him there

Deciding to take his work further afield in 2002, Banksy took his street art to the 33 1/3 Gallery in Los Angeles, USA, where he put on a show entitled Existencilism. This is a combination of the words 'stencil' and 'existentialism'. He also paid a visit to Sydney and Melbourne in Australia, where he left some of his trademark rats as a calling card.

Sometimes Banksy has painted slogans appearing like official notices. At various well-known landmarks he has stencilled 'This is not a photo opportunity'; elsewhere he has stencilled 'By Order of the National Highways Agency this Wall is a designated graffiti area'. These signs often remained for some time before anyone noticed that they had not been put there by city councils.

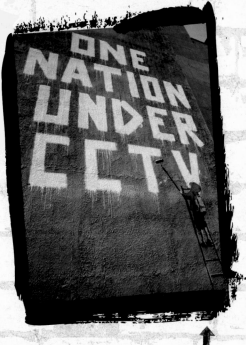

Banksy's *One Nation Under CCTV*, Oxford Street, London – June 2008

THE PEOPLE WHO TRULY DEFACE OUR NEIGHBOURHOODS ARE THE COMPANIES THAT SCRAWL GIANT SLOGANS ACROSS BUILDINGS AND BUSES, TRYING TO MAKE US FEEL INADEQUATE UNLESS WE BUY THEIR STUFF.

BANKSY

AS Banksy's fame grew, his work began to appear in places other than on the street. In 2003, the pop group Blur asked him to design the cover of their album *Think Tank*. Banksy doesn't usually take on commercial work but explained, 'I've done a few things to pay the bills, and I did the Blur album. It was a good record and [the pay was] quite a lot of money.' The artwork from the album cover sold at auction for £75,000 in 2007.

BANKSY AND

In 2003, Banksy hit the headlines when he displayed a piece of his work in an art gallery – but his painting didn't get there in the usual way.

Banksy came up with an idea he believed nobody had tried before: adding graffiti to classically-styled oil paintings. To establish the idea as his own, Banksy decided that his work should appear in a famous art gallery. He wasn't expecting an invitation any time soon, so he took matters into his own hands. Heavily disguised, he took a piece of his work into Tate Britain, a gallery in London, and simply stuck it on the wall himself when nobody was looking.

The picture was of an idyllic country scene to which he had added a stencil of police tape, the kind used to cordon off crime scenes. He put a label next to the work which read: (Banksy 1975). Crimewatch UK Has Ruined The Countryside For All Of Us. 2003. Oil On Canvas.

The painting was only discovered when it crashed to the floor a few hours later. His act, however short-lived, led to mass exposure for Banksy and his work, as the story was covered on the national news.

TATE BRITAIN

Painting in the style of Degas with an image of Simon Cowell

They seek him here, they seek him there

Banksy put another version of the painting he left at Tate Britain up for sale in London's Tom Tom gallery, along with a video of himself secretly hanging the painting in Tate Britain.

In a witty response, Tate Britain issued a statement saying that a 'man had left a personal possession in one of the galleries' and that it was 'currently being held in lost property'.

Banksy went on to add a few more of his own masterpieces to vacant spaces in art galleries, including a copy of Leonardo Da Vinci's famous *Mona Lisa* holding a bazooka rocket.

> IT WAS FUNNY; I WAS GOING INTO ALL THESE GALLERIES BUT I WASN'T LOOKING AT THE ART; I WAS LOOKING AT THE BLANK SPACES.'
>
> BANKSY

EXHIBITIONS

In 2003, Banksy decided the time was right to hold an exhibition of his work. He doesn't really like art galleries, so he put on a show in his own distinctive way.

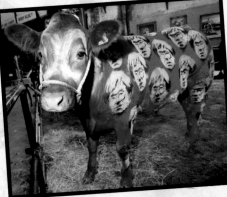

Renting a massive warehouse, Banksy put together his Turf Wars exhibition. The show ran for five days in East London. It was no ordinary spectacle. His exhibits featured live animals that were painted in various ways, one example being a cow covered in images of Andy Warhol's face. The animals he used were all show animals and used to being on public view. The paint was animal-friendly, too. The RSPCA said that the conditions were good enough, but some animal rights campaigners didn't agree: one person chained themselves to some nearby railings in protest.

A PART OF ME WISHES I COULD GO [TO THE TURF WARS EXHIBITION] BECAUSE I'VE PUT TOGETHER A REALLY NICE SETUP.

BANKSY

Banksy also held a 12-day exhibition in London in 2005. This featured classic paintings with some of his distinctive added touches – such as Monet's famous water lily pond to which Banksy added an abandoned shopping trolley.

Barely Legal was an exhibition put on by Banksy in 2006, this time in Los Angeles, USA. Once again the show featured painted live animals. The star of the show was an elephant painted pink and gold to match the wallpaper which it stood in front of. Many people thought this symbolised the idea that we sometimes don't see what's right in front of us.

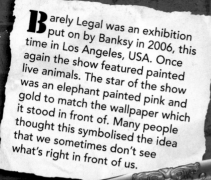

Village Pet Store and Charcoal Grill was Banksy's first official exhibition in New York, held during 2008. The show included moving puppets of a chicken watching over little chicken nuggets as they pecked away at a packet of barbecue sauce.

In the summer of 2009, people queued for hours to see Banksy's Summer Exhibition in Bristol, the city it is thought he comes from. The exhibition was held at the Bristol City Museum and Art Gallery and featured more than 100 of his works, many of which were new. His art was displayed in and among the museum's regular exhibits.

CONTROVERSIAL

The massive concrete wall separating Israel from the Palestinian territories proved too much of a temptation for Banksy to resist in 2005. The Israeli authorities say that they built the wall to protect Israel from suicide bombers, but the United Nations has declared the wall illegal. With a statement on his website saying that he believes the wall, 'essentially turns Palestine into the world's largest open prison', Banksy set off to express his views on the subject through his art.

WHAT ARE YOU LOOKING AT?

He created nine murals on the wall, each sending a subtle message to the world. One showed a silhouette of a girl floating up holding on to a bunch of balloons. Another showed comfortable-looking armchairs by a window with a beautiful view through it.

A WALL HAS ALWAYS BEEN THE BEST PLACE TO PUBLISH YOUR WORK. BANKSY

THEMES

Guantanamo Bay is an American prison for suspected terrorists in Cuba. Some people believe that the people held there may be a threat to security, but others think that the prison should be closed and that the prisoners held there should either be charged with a crime or released. To make people think about the issue, in 2006 Banksy dressed an inflatable doll in orange overalls to look like a Guantanamo prisoner, then placed the doll in Disneyland, California.

In 2004, for the seventh anniversary of Princess Diana's death, Banksy printed some mock £10 notes with her face on them instead of the Queen's. On the fake money was written: 'Bansky of England. I promise to pay the bearer on demand 'the ultimate price.' Take a look at a real £10 note to see what is actually written on it.

> IF YOU WANT TO SAY SOMETHING AND HAVE PEOPLE LISTEN THEN YOU HAVE TO WEAR A MASK. IF YOU WANT TO BE HONEST THEN YOU HAVE TO LIVE A LIE.
>
> BANKSY

> THE GREATEST CRIMES IN THE WORLD ARE NOT COMMITTED BY PEOPLE BREAKING THE RULES BUT BY PEOPLE FOLLOWING THE RULES. IT'S PEOPLE WHO FOLLOW ORDERS THAT DROP BOMBS AND MASSACRE VILLAGES.
>
> BANKSY

During the London Olympics in 2012, Banksy painted some controversial images on to walls and put photographs of them on his website. One mural showed an athlete throwing a javelin shaped like a missile. Another showed an athlete pole-vaulting over a fence on to a dirty old mattress.

BANKSY IN GAZA

Banksy's art always has something to say. His messages can be humorous or political – and are often both. He expresses himself in a way that gets noticed. In 2015, 10 years after his first visit, Banksy returned to Gaza in Palestine and added some new paintings to the war-torn area.

One painting, on the last piece of a ruined building still standing, features a cute kitten. In front of the wall is a rusty bundle of metal which looks like a ball of wool that the kitten is playing with. One local person commented, 'This cat tells the whole world that she is missing joy in her life. The cat found something to play with. What about our children?'

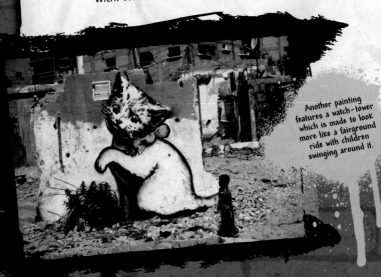

Another painting features a watch-tower which is made to look more like a fairground ride with children swinging around it.

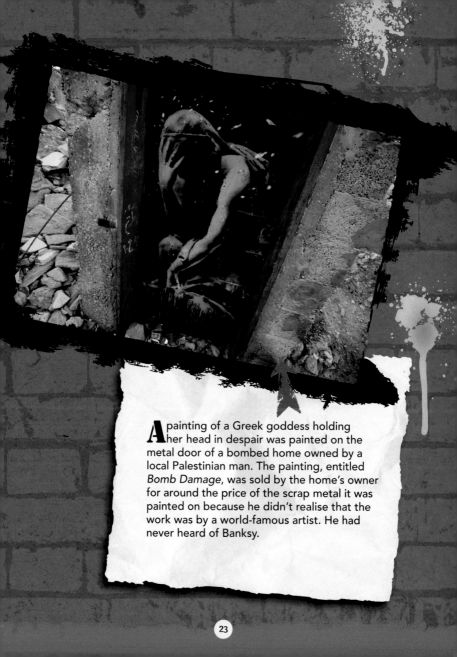

A painting of a Greek goddess holding her head in despair was painted on the metal door of a bombed home owned by a local Palestinian man. The painting, entitled *Bomb Damage*, was sold by the home's owner for around the price of the scrap metal it was painted on because he didn't realise that the work was by a world-famous artist. He had never heard of Banksy.

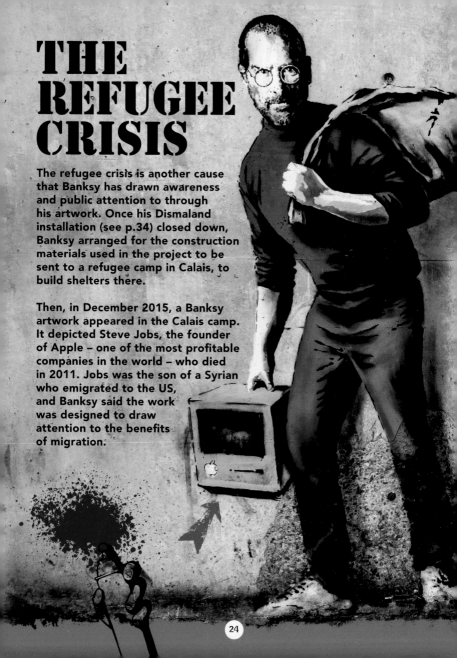

THE REFUGEE CRISIS

The refugee crisis is another cause that Banksy has drawn awareness and public attention to through his artwork. Once his Dismaland installation (see p.34) closed down, Banksy arranged for the construction materials used in the project to be sent to a refugee camp in Calais, to build shelters there.

Then, in December 2015, a Banksy artwork appeared in the Calais camp. It depicted Steve Jobs, the founder of Apple – one of the most profitable companies in the world – who died in 2011. Jobs was the son of a Syrian who emigrated to the US, and Banksy said the work was designed to draw attention to the benefits of migration.

WE'RE OFTEN LED TO BELIEVE MIGRATION IS A DRAIN ON THE COUNTRY'S RESOURCES BUT STEVE JOBS WAS THE SON OF A SYRIAN MIGRANT. APPLE IS THE WORLD'S MOST PROFITABLE COMPANY, IT PAYS OVER $1BN (£4.6BN) A YEAR IN TAXES – AND IT ONLY EXISTS BECAUSE THEY ALLOWED IN A YOUNG MAN FROM HOMS.

BANKSY

In January 2016, a Banksy mural appeared opposite the French Embassy in Knightsbridge, in London. It depicts a female character from the musical *Les Misérables* in a cloud of tear gas, with tears in her eyes and an empty can of tear gas at her feet. A QR code next to the image links directly to a video of French authorities appearing to use tear gas in a raid on a refugee camp in Calais.

The original work was painted on a temporary wooden structure that was part of some existing building works, and was removed soon after. However, Google decided to digitise the work before it was taken down, and so it can be seen on StreetView.

IS IT RACIST?

In September 2014, a mural appeared in an English seaside resort called Clacton-on-Sea. The painting showed a group of grey pigeons and one colourful swallow. The pigeons held signs with messages for the swallow including 'Go back to Africa' and 'Keep off our worms'.

The district council removed the painting after a member of the public complained to them that it contained 'offensive and racist remarks'.

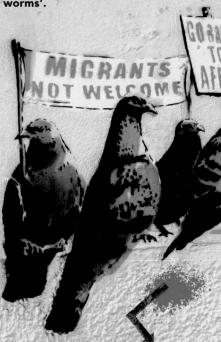

The painting appeared a week before a by-election in the town which was happening because the local Conservative MP, Douglas Carswell, decided to join another political party, the UK Independence Party (UKIP), which has anti-immigration policies.

Some people feel that the messages in Banksy's work were intended to be ironic, as many people welcome the contribution that immigrants bring to the country. Others read the signs, take the meaning very literally, and think they are offensive.

'WE WOULD OBVIOUSLY WELCOME AN APPROPRIATE BANKSY ORIGINAL ON ANY OF OUR SEAFRONTS AND WOULD BE DELIGHTED IF HE RETURNED IN THE FUTURE.'
– NIGEL BROWN, COMMUNICATIONS MANAGER FOR CLACTON-ON-SEA COUNCIL

EXIT
THROUGH

When Banksy turned his hand to film-making, the result was an award-winning documentary. Premiered at the Sundance Film Festival in the USA, his film raised more questions than it answered, and caused quite a stir.

Exit *Through the Gift Shop* is a movie directed by Banksy and released in 2010. Filmed as a documentary, it is about Thierry Guetta, a Frenchman living in Los Angeles who is obsessed with street artists at work. Although Thierry had wanted to film Banksy more than any other street artist, Banksy decided that Thierry was an interesting character and made his own movie about him. Banksy suggested to Thierry that he could become a street artist himself and so, taking his advice, he reinvented himself as Mr Brainwash, or MBW for short. MBW is now a successful artist and his work sells for high prices.

Street art by Mr Brainwash outside The Old Sorting Office, London, venue for his first solo show – September 2012

IT'S BASICALLY THE STORY OF HOW ONE MAN SET OUT TO FILM THE UN-FILMABLE. AND FAILED.
BANKSY

THE GIFT SHOP

Banksy's film was nominated for quite a few awards, including an Oscar for 'Best Documentary' and a BAFTA for 'Outstanding Debut by a British Writer, Director or Producer'. He won 'Best Documentary' at the Austin Film Critics Award and an Eddie (American Cinema Editors Award) for 'Best Edited Documentary'.

When hearing of his Oscar nomination, Bansky said:

'THIS IS A BIG SURPRISE … I DON'T AGREE WITH THE CONCEPT OF AWARD CEREMONIES, BUT I'M PREPARED TO MAKE AN EXCEPTION FOR THE ONES I'M NOMINATED FOR.'

Another controversial piece of street art by Mr Brainwash (aka Thierry Guetta) at his first UK solo show – September 2012

They seek him here, they seek him there

Because MBW's art was very similar to Banksy's own style, many people thought that the film was a hoax and that MBW was actually Banksy in disguise. Others thought that MBW was an actor, a living piece of art rather than a genuine character. Banksy, who doesn't usually confirm or deny any rumours, insisted that it was all true. Whichever version is correct, the film was a success and won many awards.

BETTER OUT THAN IN

In October 2013, Banksy put on an outdoor art show on the streets of New York. His aim was to create a new piece of art for every day of October. Banksy promised:

> 'A UNIQUE KIND OF ART SHOW …'

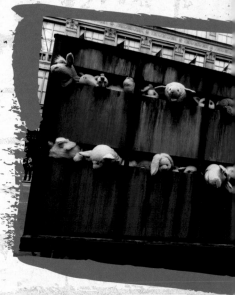

It featured, in Banksy's words, 'elaborate graffiti, large scale street sculpture, video installations, and substandard performance art'. In a newspaper interview which took place by email, so that he could remain anonymous, Banksy explained:

> 'THE PLAN IS TO LIVE HERE, REACT TO THINGS, SEE THE SIGHTS – AND PAINT ON THEM. SOME OF IT WILL BE PRETTY ELABORATE, AND SOME WILL JUST BE A SCRAWL ON A TOILET WALL.'

When asked the reason for the show, he said:

> 'THERE IS ABSOLUTELY NO REASON FOR DOING THIS SHOW AT ALL.'

Banksy's show aimed to turn the city into a giant treasure hunt. Spotting his work was difficult though, because it sometimes disappeared as quickly as it had appeared, either being drawn over by other graffiti artists or removed by the authorities. The show also featured installations. In one piece, a truck covered in graffiti contained a scene of virtual paradise, complete with a waterfall.

They seek him here, they seek him there

Banksy set up a stall selling original pieces of his work for $60 (about £40) on the streets of New York. The lucky few who bought paintings now own work that would sell for thousands of dollars, but most people just walked straight past.

For the duration of the show, Banksy communicated his ideas to the public through his website. He also posted a video installation on his website. The show came complete with a phone number providing a guided tour of his pieces around the city. The recording was styled as a mock version of audio tours commonly found in museums and galleries.

NEW YORK CALLS TO GRAFFITI WRITERS LIKE A DIRTY OLD LIGHTHOUSE. WE ALL WANT TO PROVE OURSELVES HERE. I CHOSE IT FOR THE HIGH FOOT TRAFFIC AND THE AMOUNT OF HIDING PLACES. MAYBE I SHOULD BE SOMEWHERE MORE RELEVANT, LIKE BEIJING OR MOSCOW, BUT THE PIZZA ISN'T AS GOOD. BANKSY

Another truck, usually used to transport farm animals, roamed the streets of New York containing happy-looking puppet animals. There was even some performance art, where a fibreglass model of Ronald McDonald had his big clown-shoes polished by an actor dressed as a street child.

BANKSY'S YOUTH

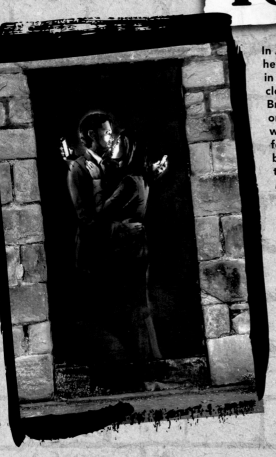

In April 2014, Banksy gave a helping hand to a youth club in Bristol that was facing closure. Banksy heard that Broad Plain Boys Club, an organisation that has been working with young people for more than 100 years, badly needed funding to stay open. His work, *Mobile Lovers*, which was painted on a plank of wood, was screwed to a door in Clement Street at the club's headquarters. Club members carefully removed the painting and Dennis Stinchcombe, the club's owner, put it on display for people to view in exchange for optional donations.

CLUB DOOR

Word of Banksy's new piece of art spread quickly, and it was taken away by the police and handed over to Bristol City Council, who decided to put it on display at the Bristol Museum and Art Gallery.

Members of the Broad Plain Boys Club were upset because they had hoped the donations from viewings would be enough to keep them open. Banksy decided to step in and write a letter to Dennis Stinchcombe saying, 'as far as I'm concerned you can have it'.

The Banksy piece that has become known as Mobile Lovers shows a couple embracing while each of them checks their phone over the other's shoulders.

'THE SIGNIFICANCE OF THIS WORK, AND OF THE ORIGINAL PLACING OF THE WORK BY BANKSY, IS IMMENSE. IT'S A SEMINAL PIECE, PURE BANKSY, MADE EVEN MORE REMARKABLE BY ITS INTENT. IT'S A VERY GENEROUS GESTURE, AND IT'S NOTEWORTHY THAT AN ARTIST RISEN FROM THE STREET HAS GIVEN BACK SO PROMINENTLY TO THE STREET.'

– MARY MCCARTHY, ART EXPERT

Mobile Lovers remained on display at the Bristol Museum and Art Gallery until it was sold in August of the same year with proceeds going to Broad Plain. Dennis Stinchcombe said: 'Mobile Lovers has been a fantastic gift to us; without it, the club would definitely have shut within the next 12 months or so.'

The story had a happy ending for the youth club. George Ferguson, mayor of Bristol, said: 'I'm delighted with the outcome and grateful to Banksy for letting it be known that he would be happy for proceeds from a sale to benefit a Bristol club that does so much good for local young people.'

A 'Thanks Banksy' wall was made by the youth club members and erected on the Broad Plain boundary fence so that everyone, including Banksy, would see it as they drove up the M32 into Bristol.

DISMALAND
BEMUSEMENT
PARK

During August 2015, a temporary art project organised by Banksy opened for five weeks in Weston-super-Mare, an English seaside town close to Bristol. He said the show was a 'family theme park unsuitable for children'.

The exhibition took place in a disused open-air swimming pool complex, the Tropicana. Describing it as 'a sinister twist on Disneyland', Banksy invited 60 artists to contribute. Of this group, 58 agreed, including the famous and controversial artist Damien Hirst.

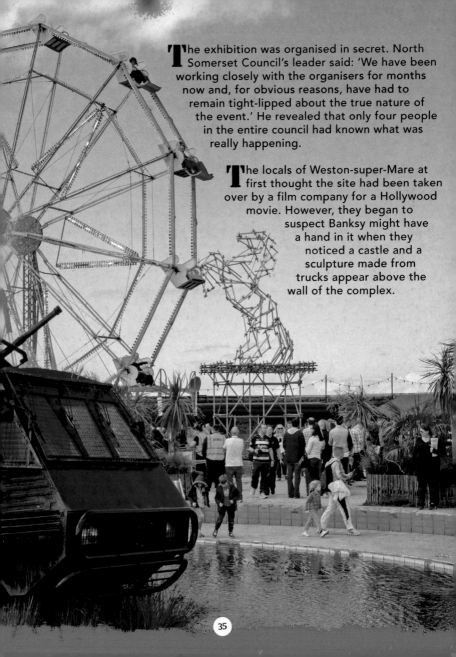

The exhibition was organised in secret. North Somerset Council's leader said: 'We have been working closely with the organisers for months now and, for obvious reasons, have had to remain tight-lipped about the true nature of the event.' He revealed that only four people in the entire council had known what was really happening.

The locals of Weston-super-Mare at first thought the site had been taken over by a film company for a Hollywood movie. However, they began to suspect Banksy might have a hand in it when they noticed a castle and a sculpture made from trucks appear above the wall of the complex.

The Tropicana outdoor pool had closed in 2000 because of falling visitor numbers. It had remained empty since then with plans to either demolish it or reopen it discussed in turn. When Banksy's show opened, people flocked to Weston-super-Mare to queue for £3.00 tickets. The old site was once again a hive of activity.

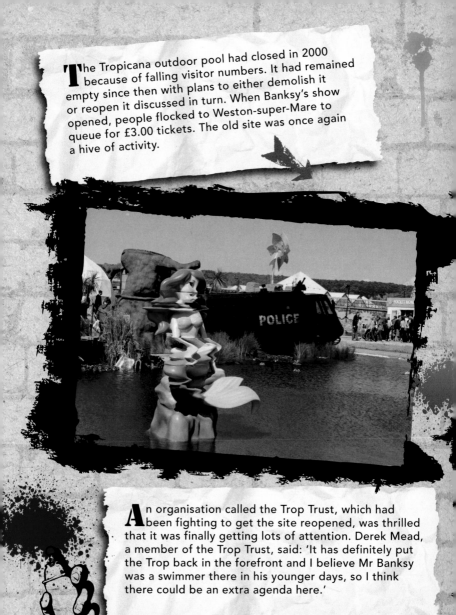

An organisation called the Trop Trust, which had been fighting to get the site reopened, was thrilled that it was finally getting lots of attention. Derek Mead, a member of the Trop Trust, said: 'It has definitely put the Trop back in the forefront and I believe Mr Banksy was a swimmer there in his younger days, so I think there could be an extra agenda here.'

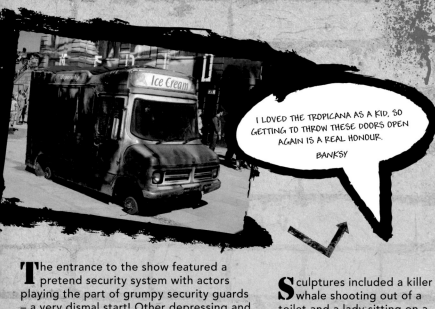

> I LOVED THE TROPICANA AS A KID, SO GETTING TO THROW THESE DOORS OPEN AGAIN IS A REAL HONOUR.
>
> *BANKSY*

The entrance to the show featured a pretend security system with actors playing the part of grumpy security guards – a very dismal start! Other depressing and cynical features included the Grim Reaper on a bumper car dancing to the song *Staying Alive* and an unpleasant-looking version of Cinderella's castle.

Sculptures included a killer whale shooting out of a toilet and a lady sitting on a bench whilst being engulfed by a flock of birds.

It has been estimated that the exhibition contributed £20 million of business to Weston-super-Mare.

> I GUESS YOU'D SAY IT'S A THEME PARK WHOSE BIG THEME IS 'THEME PARKS SHOULD HAVE BIGGER THEMES.'
>
> *BANKSY*

BANKSY'S CRITICS

Many people admire Banksy, but not everyone is a fan. He has almost as many critics as he has admirers – some are from the authorities and, surprisingly, some are other graffiti artists.

'JUST BECAUSE IT'S URBAN AND OUTSIDE DOESN'T MAKE IT ANY GOOD.'
– JONATHAN JONES, ART CRITIC

While Banksy's street art is often protected by perspex guards and sought out by curious tourists, some people take a different view of his work. Tower Hamlets Council in London has decided to treat his work as vandalism. It has removed any Banksy art that has appeared and will continue to do so. A statement said:

'TOWER HAMLETS COUNCIL TAKES THE CLEANLINESS OF THE BOROUGH VERY SERIOUSLY AND IS COMMITTED TO REMOVING ALL GRAFFITI AS SOON AS POSSIBLE.'

It went on to explain that many of their residents think graffiti is an eyesore, saying that it makes their neighbourhoods feel less safe. It also costs thousands of pounds every year to clean it up.

Fellow street artists have been known to criticise Banksy too. Some reject his use of stencils, saying that his work is not true graffiti. They have also criticised him for becoming a 'sell-out', now that he is famous and his work sells for high prices. During his street show in New York, Banksy's website featured a FAQ section which included the question: 'Why are you such a sell-out?' and the answer: 'I wish I had a pound for every time someone asked me that.'

I USED TO THINK OTHER GRAFFITI WRITERS HATED ME BECAUSE I USED STENCILS, BUT THEY JUST HATE ME.
BANKSY

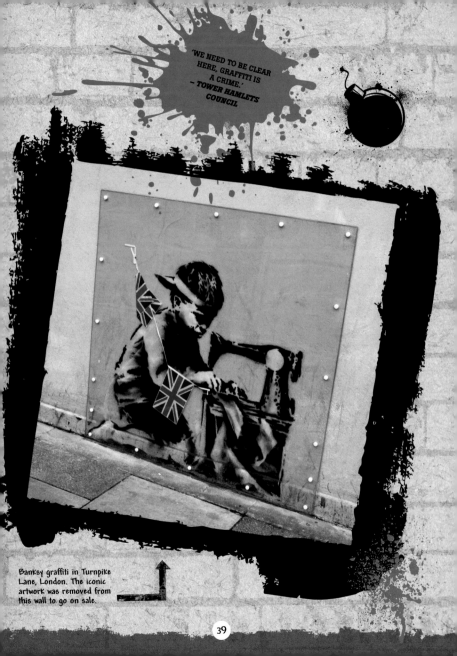

'WE NEED TO BE CLEAR HERE, GRAFFITI IS A CRIME.'
– TOWER HAMLETS COUNCIL

Banksy graffiti in Turnpike Lane, London. The iconic artwork was removed from this wall to go on sale.

MOST FAMOUS WORKS

Banksy's distinctively styled satirical stencils are known the world over. There are some themes and images that he has created repeatedly over the years, which have become particularly famous.

Banksy's monkeys are more than a little cheeky. Often they display messages on sandwich boards. Sometimes they pose as the Queen of England, and occasionally they are even in possession of explosives!

Rats have always been a big favourite with Banksy, perhaps because they are rarely seen, even though they exist in their millions as a part of city life – rather like the millions of people who feel that they are not heard in modern life. Sometimes wearing necklaces, often holding a placard, many times with a camera: the Banksy rat is a creature of mischief.

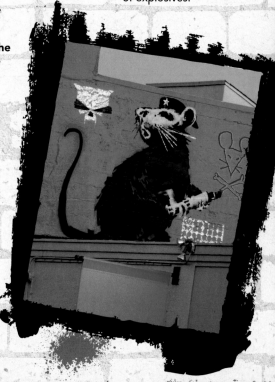

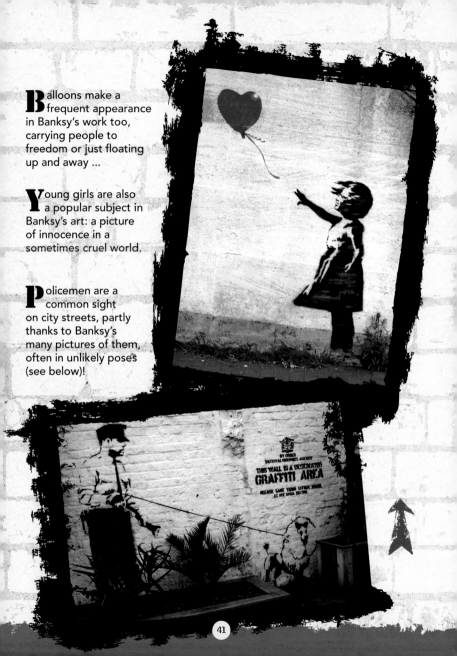

Balloons make a frequent appearance in Banksy's work too, carrying people to freedom or just floating up and away ...

Young girls are also a popular subject in Banksy's art: a picture of innocence in a sometimes cruel world.

Policemen are a common sight on city streets, partly thanks to Banksy's many pictures of them, often in unlikely poses (see below)!

BANKSY'S BOOKS

Banksy produced his work in a more conventional format when he wrote and published a series which he refers to as his 'three little books'.

Banging Your Head Against a Brick Wall was published in 2001, **Existencilism** followed in 2002 and **Cut It Out** was published in 2004. The short books were published by Banksy's company, Weapons of Mass Distraction. They contain photos of his work and his thoughts about them.

Much street art is produced by unknown street artists. Banksy featured images like these in his book *Pictures of Walls* (below and top right).

A WALL IS A VERY BIG WEAPON. IT'S ONE OF THE NASTIEST THINGS YOU CAN HIT SOMEONE WITH.

BANKSY

A LOT OF MOTHERS WILL DO ANYTHING FOR THEIR CHILDREN, EXCEPT LET THEM BE THEMSELVES

BANKSY

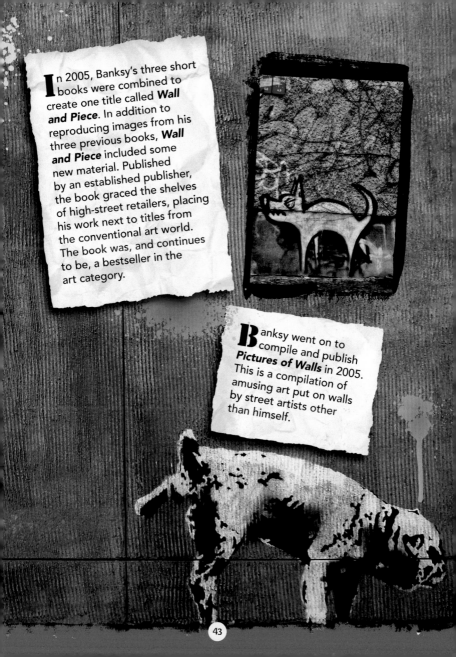

In 2005, Banksy's three short books were combined to create one title called **Wall and Piece**. In addition to reproducing images from his three previous books, **Wall and Piece** included some new material. Published by an established publisher, the book graced the shelves of high-street retailers, placing his work next to titles from the conventional art world. The book was, and continues to be, a bestseller in the art category.

Banksy went on to compile and publish **Pictures of Walls** in 2005. This is a compilation of amusing art put on walls by street artists other than himself.

IN THE WILD

Here are some places you can spot a Banksy in its original setting:

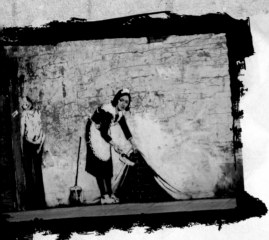

LONDON

There are more Banksy artworks in this city than anywhere else, except perhaps Bristol. Some have been removed, painted over or taken away and sold. However, others remain including this, *Sweeping it Under the Carpet*, which can be seen on a wall in Chalk Farm, a neighbourhood in the north of the city.

BRISTOL

Banksy's home town is bedecked with his artwork, and you can even do a Banksy-themed walking tour of the city. Here you can see his Grim Reaper, a masked gorilla and this mural, entitled *The Mild Mild West*.

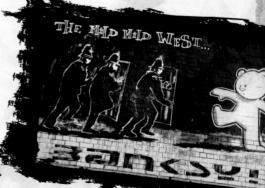

ISRAEL/PALESTINE

Banksy has a long history of creating work around conflict zones in Israel and Palestine. In 2005, he painted nine artworks on the controversial West Bank barrier – a structure that runs through both Israeli and Palestinian territory. In 2015, Banksy visited Gaza, where he created artworks including an image of children swinging on a watch-tower as if it were a fairground ride.

SOMERSET

Banksy chose the picturesque Cheddar Gorge in Somerset as the setting for the words 'This is not a photo opportunity' stencilled on to a rock. Banksy artwork has also popped up in the town of Weston-super-Mare, which hosted his 'bemusement park' in 2015.

NORTH AMERICA

Many of Banksy's US artworks have been painted over or removed, but a few still remain. This one in New York, from his 2013 outdoor show *Better Out Than In*, has been protected by a piece of clear plastic to preserve it. Banksy's art has also appeared in cities ranging from Boston, San Francisco and Utah to Los Angeles, Detroit and Toronto, in Canada.

Banksy's distinctive artwork has also popped up in locations such as Liverpool, Brighton, Cheltenham, Paris, Greece and Australia, to name but a few, so wherever you are in the world, keep your eyes peeled and you might just spot a Banksy!

FIND OUT MORE

BOOKS ...

... BY BANKSY

Wall and Piece (The Random House Group, 2005)

Pictures of Walls, conceived and compiled by Banksy (Picturesofwalls Limited, 2005)

... ABOUT BANKSY

Banksy: The Man Behind the Wall, by Will Elsworth-Jones (Aurum Press Limited, 2012)

Banksy: You Are an Acceptable Level of Threat and if You Were Not You Would Know About It, by Gary Shove (Carpet Bombing Culture, 2012)

Banksy Myths & Legends, by Marc Leverton (Carpet Bombing Culture, 2012)

Planet Banksy, by Alan Ket (Michael O'Mara, 2014)

Banksy in New York, by Ray Mock (Gingko Press, 2015)

... ABOUT STREET ART

The World Atlas of Street Art and Graffiti, by Dr. Rafael Schacter and John Fekner (Aurum Press Limited, 2013)

Street Art: From Around the World, by Garry Hunter (Arcturus Publishing, 2012)

New Street Art, by Claude Crommelin (ACC Editions, 2016)

ONLINE

Banksy's official website is **www.banksy.co.uk**

You can also sometimes buy his artwork from **www.picturesonwalls.com**

Banksy has no verified social media accounts, but using #banksy to search Twitter or Instagram can yield some interesting results.

The Urban Art Association (**www.urbanartassociation.com/**) is a useful website for following street art trends and discovering new artists, as well as for advice on street art auctions and pricing.

Google Maps allows you to view the locations, and some images, of Banksy's London art **www.google.co.uk/maps**

The Banksy pool on Flickr allows users to share their own photos of Banksy's artwork, and can be viewed here: **www.flickr.com/groups/banksy/pool/**

WATCH

Exit Through the Gift Shop Banksy's award-winning 2010 documentary.

Banksy Does New York a 2014 HBO documentary capturing *Better Out Than In*, Banksy's outdoor art show in New York.

INDEX

3D 8, 9

A

art critics 12, 13
art galleries 15, 16–17, 18, 19, 31, 33
Australia 15, 45

B

balloons 20, 41
Banging Your Head Against a Brick Wall (book) 42
Barely Legal (exhibition) 19
Better Out Than In (art show) 30–31, 47
books 42–43, 46
Bristol 4, 6, 8, 14, 19, 32, 33, 44
Broad Plain Boys Club 32, 33

C

C215 11
Clacton-on-Sea 26–27
controversial themes 20–21, 22–23, 24–25, 26–27, 37
criticism of Banksy 12, 13, 27, 38–39
Cut It Out (book) 42

D

disguises 5, 16, 29
Dismaland 24, 34–37
DryBreadZ (DBZ) 8

E

early work 8–9
exhibitions 15, 18–19, 30–31, 34–37, 45
Existencilism (book) 42
Existencilism (exhibition) 15
Exit Through the Gift Shop (film) 28–29, 47

F

famous works 16–17, 18–19, 20, 21, 22, 23, 24, 25, 26, 28–29, 30–31, 34–37, 40–41, 42, 43, 44, 45
film awards 29
film-making 28–29, 47
France 5, 24, 25, 45

G

gang culture 13
Gaza 22–23, 45
graffiti 8–9, 10–11, 12–13, 14, 16, 30, 38, 46, 47
Guantanamo Bay 21
Guetta, Thierry 28, 29
Gunningham, Robin 6, 7

H

Hirst, Damien 6, 13, 34

I

identity 4, 5, 6–7, 13, 29
images, repeated 40–41
installations 16–17, 18–19, 30–31, 34–37
interviews 5, 8, 30
Israel 20, 45

L

Lazarides, Steve 8
legal street art 10
London 8, 12, 13, 14, 15, 16, 17, 18, 20, 21, 25, 44, 47

M

MBW (Mr Brainwash) 6, 28, 29
monkeys 14, 40

N

New York 8, 9, 19, 30–31, 38, 45, 47

O

Os Gemeos 11
outdoor art show 30–31, 34–37, 47

P

Palestine 14, 20, 22–23, 45
performance art 30, 31
Pictures of Walls (book) 42, 43, 46
policemen 8, 13, 14, 41

R

rats 14, 15, 40
refugee crisis 24–25
ROA 11

S

stencils 8, 14, 15, 16, 38, 40, 45
Summer Exhibition, Bristol 19

T

Tate Britain 16–17
Turf Wars (exhibition) 18

U

USA 8, 11, 14, 19, 28, 30–31, 38, 45, 47

V

Village Pet Store and Charcoal Grill (exhibition) 19

W

Wall and Piece (book) 43, 46
Weapons of Mass Distraction 42
Weston-super-Mare 34, 35, 36, 37, 45